Off The Stoop, The Book of Sasquatch, Coloring Book

Illustrator Jeffrey W. Johnson

Copyright Material

2016

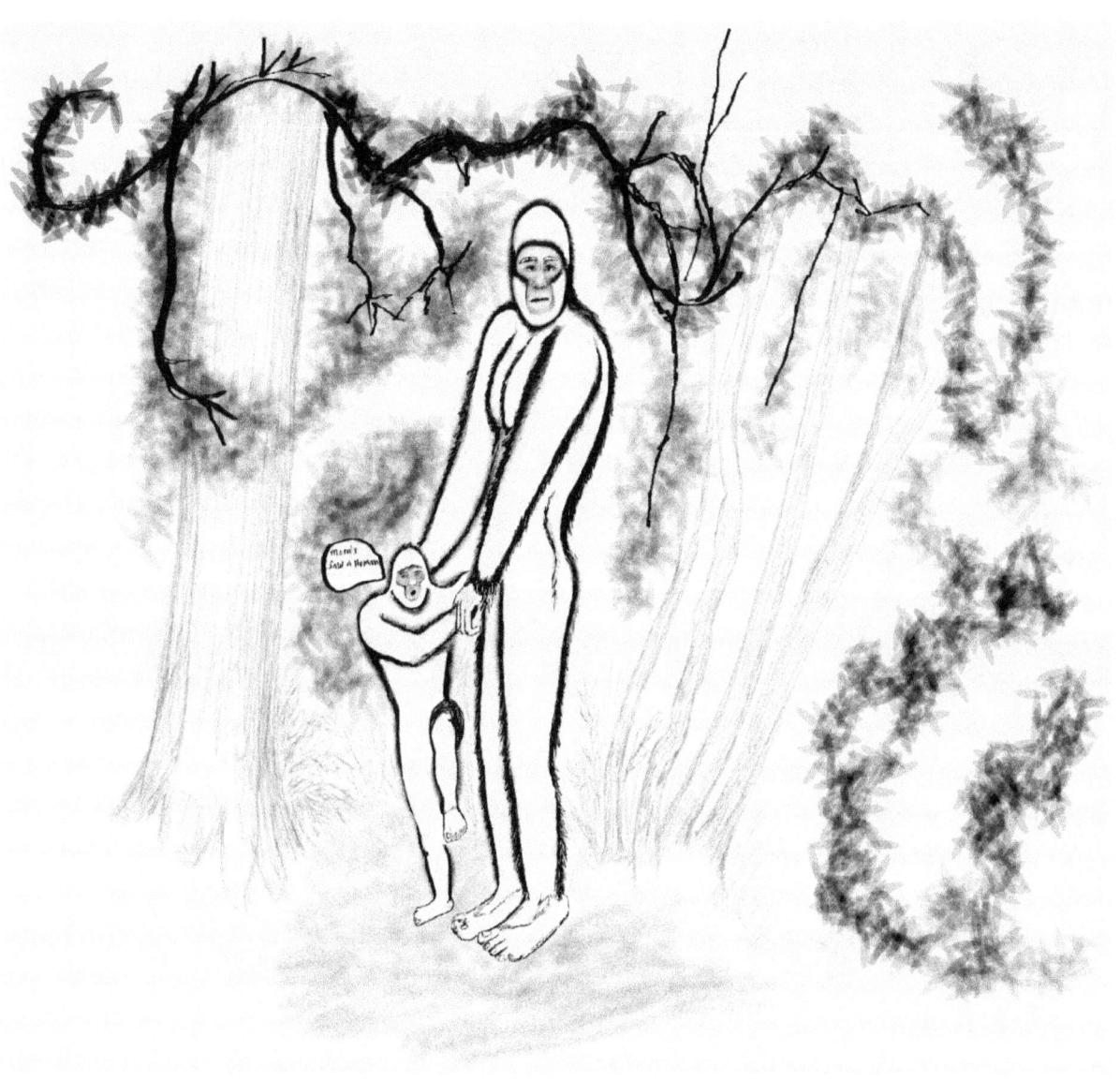

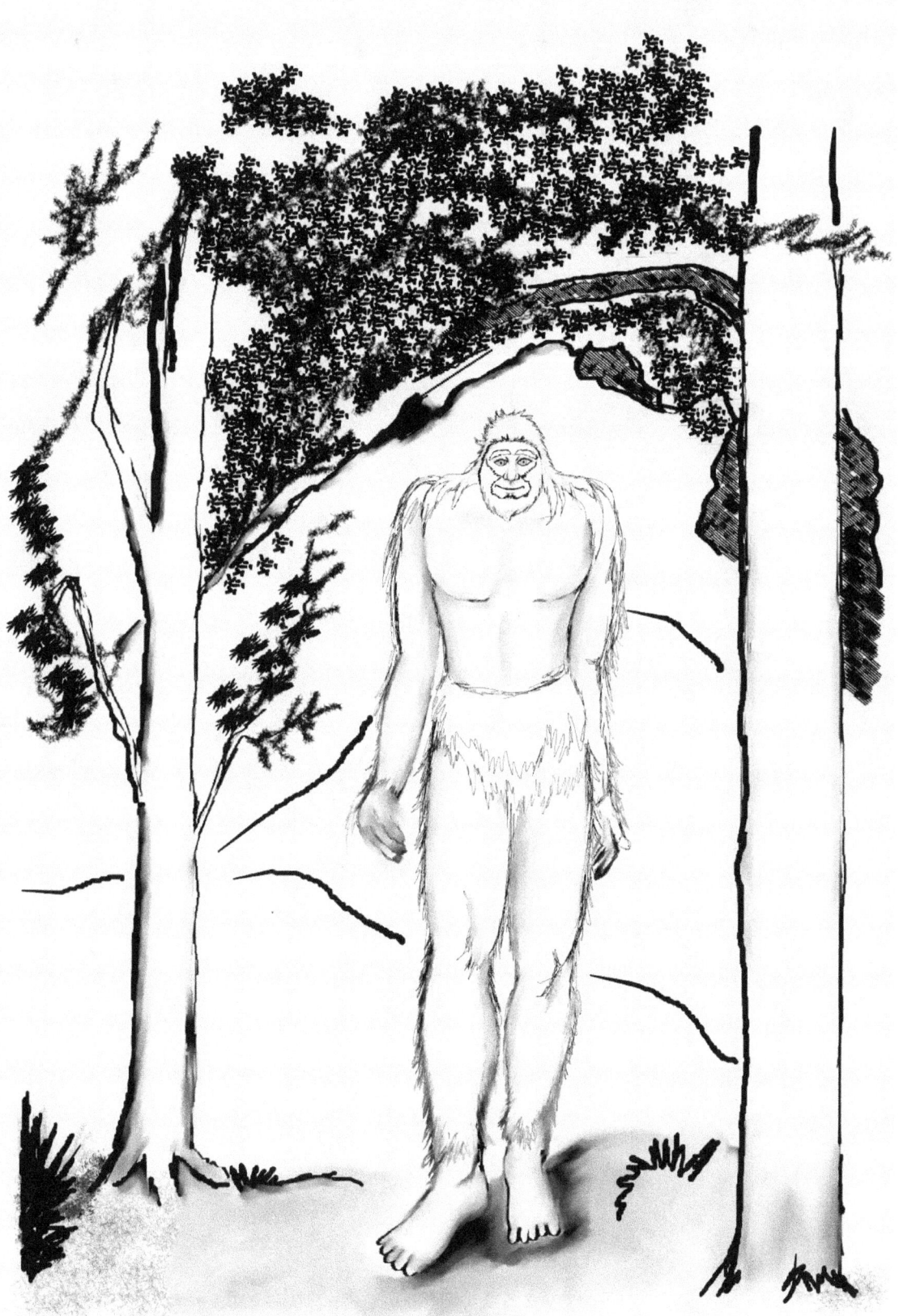

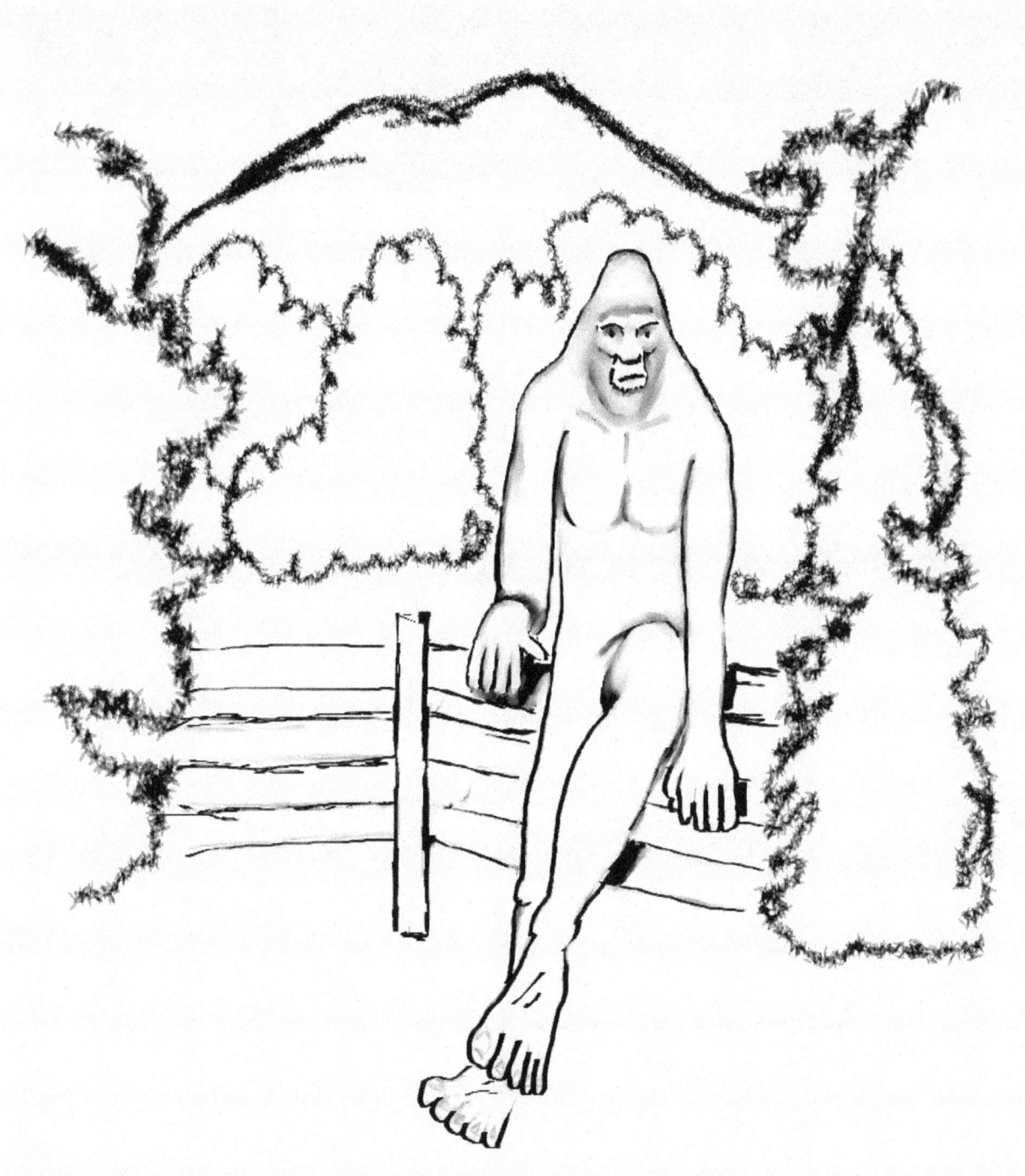

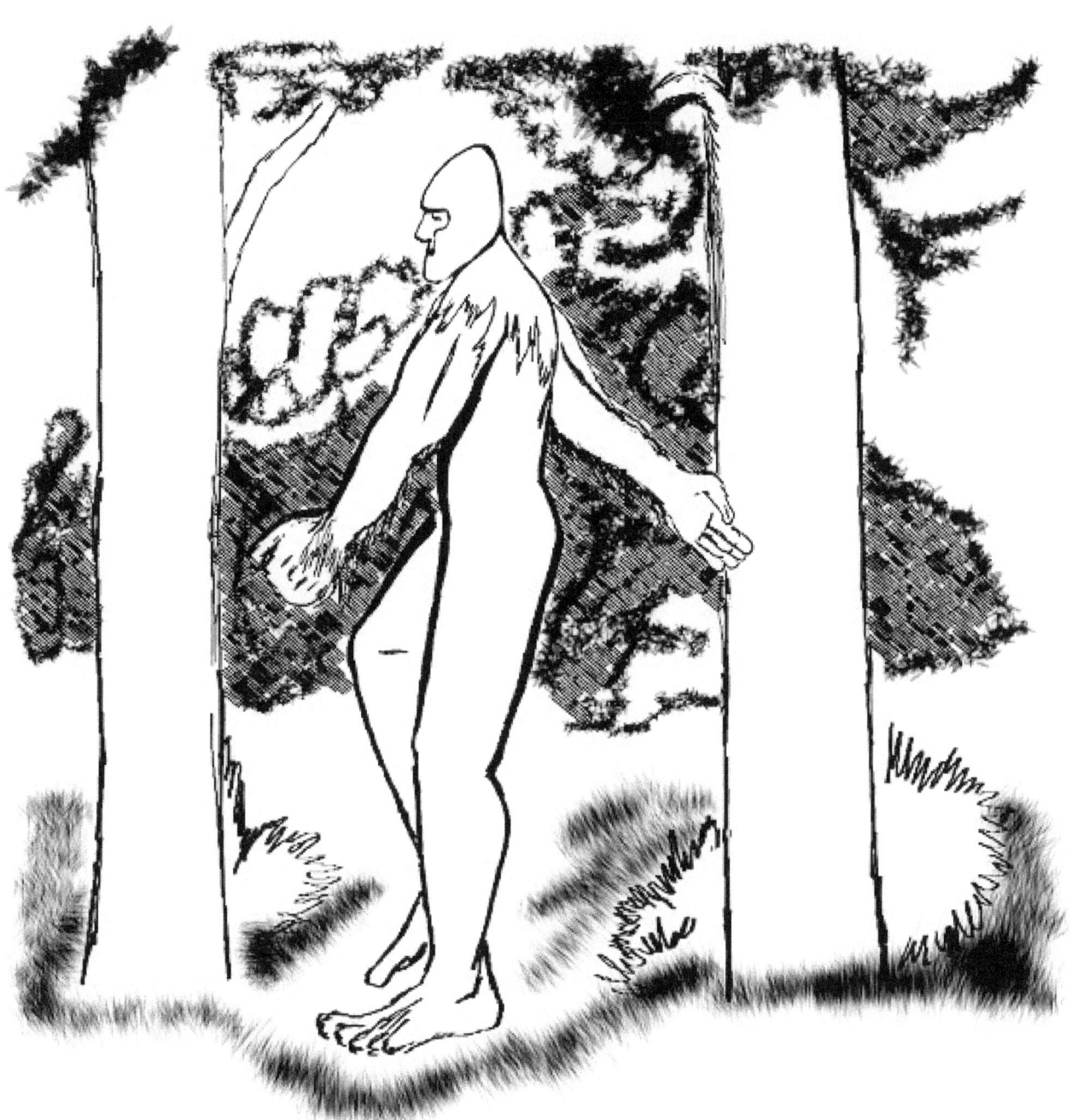

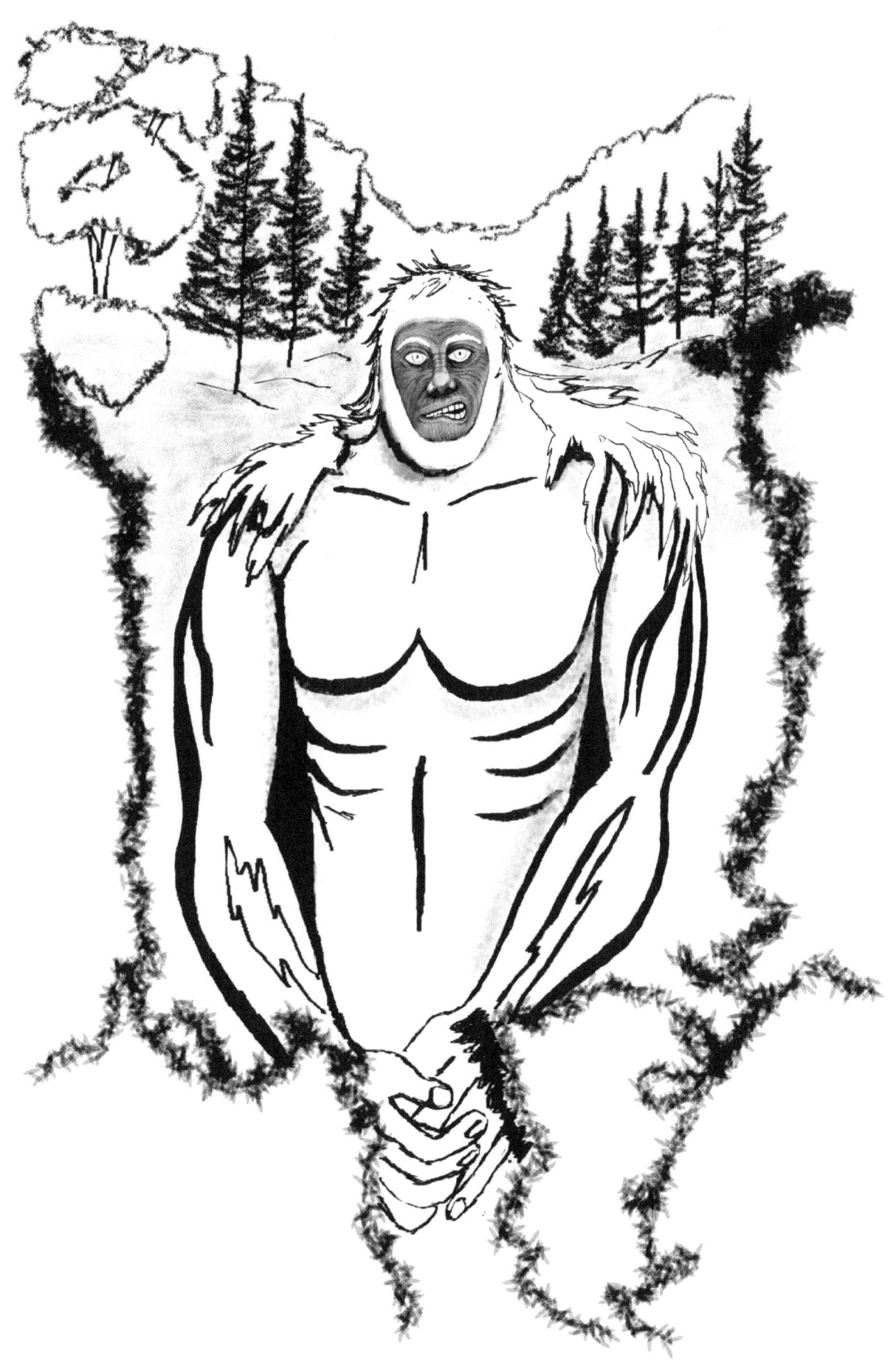

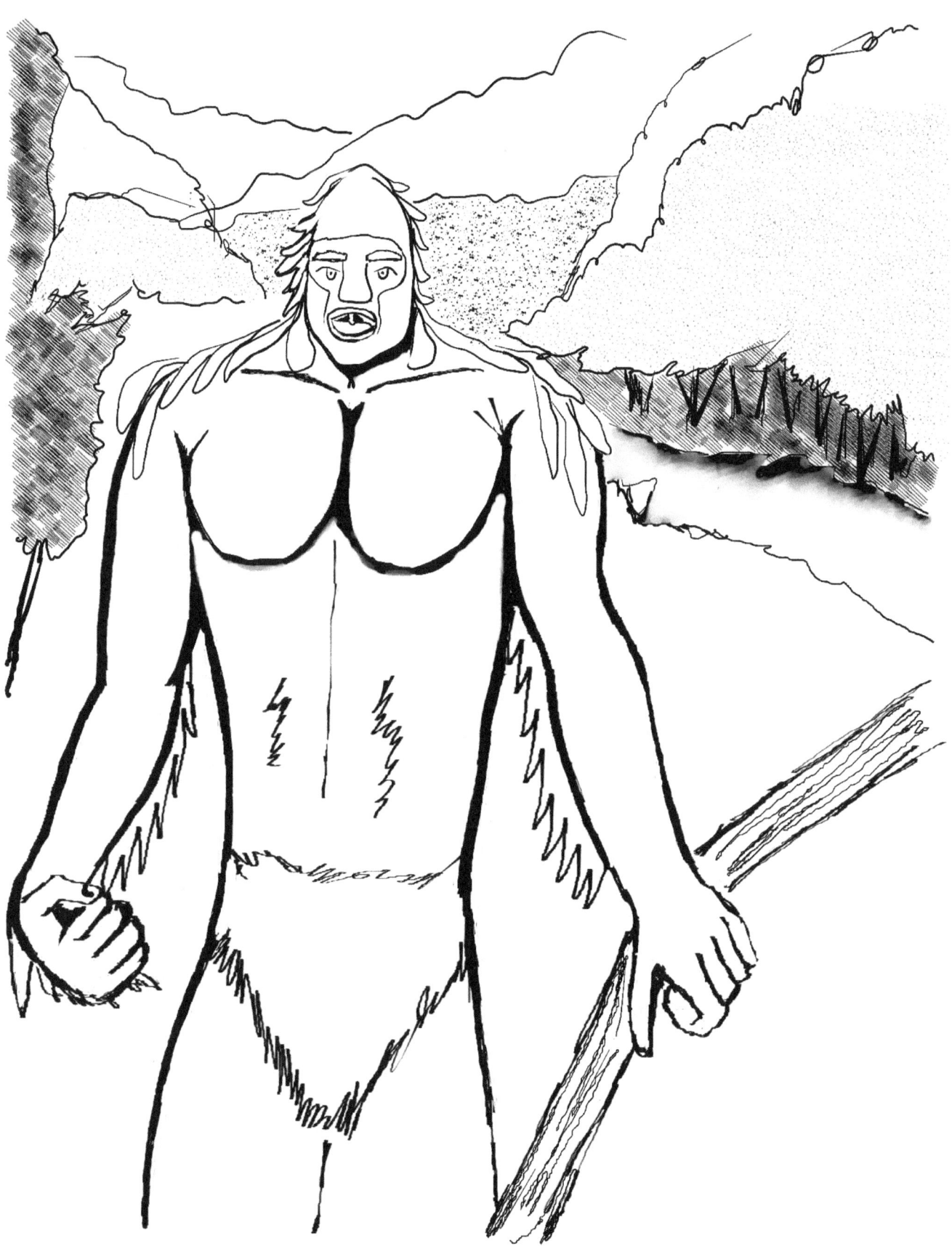

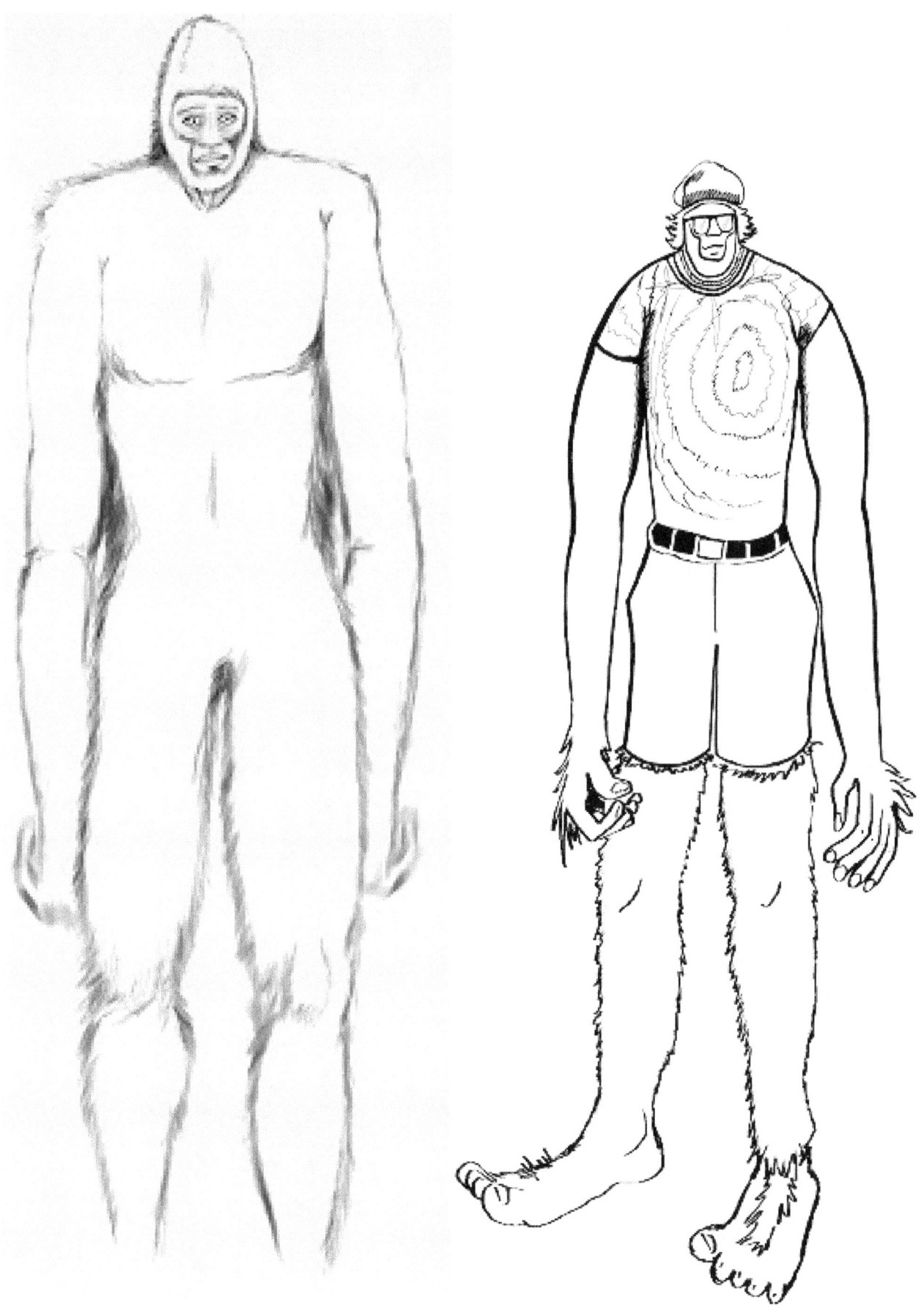

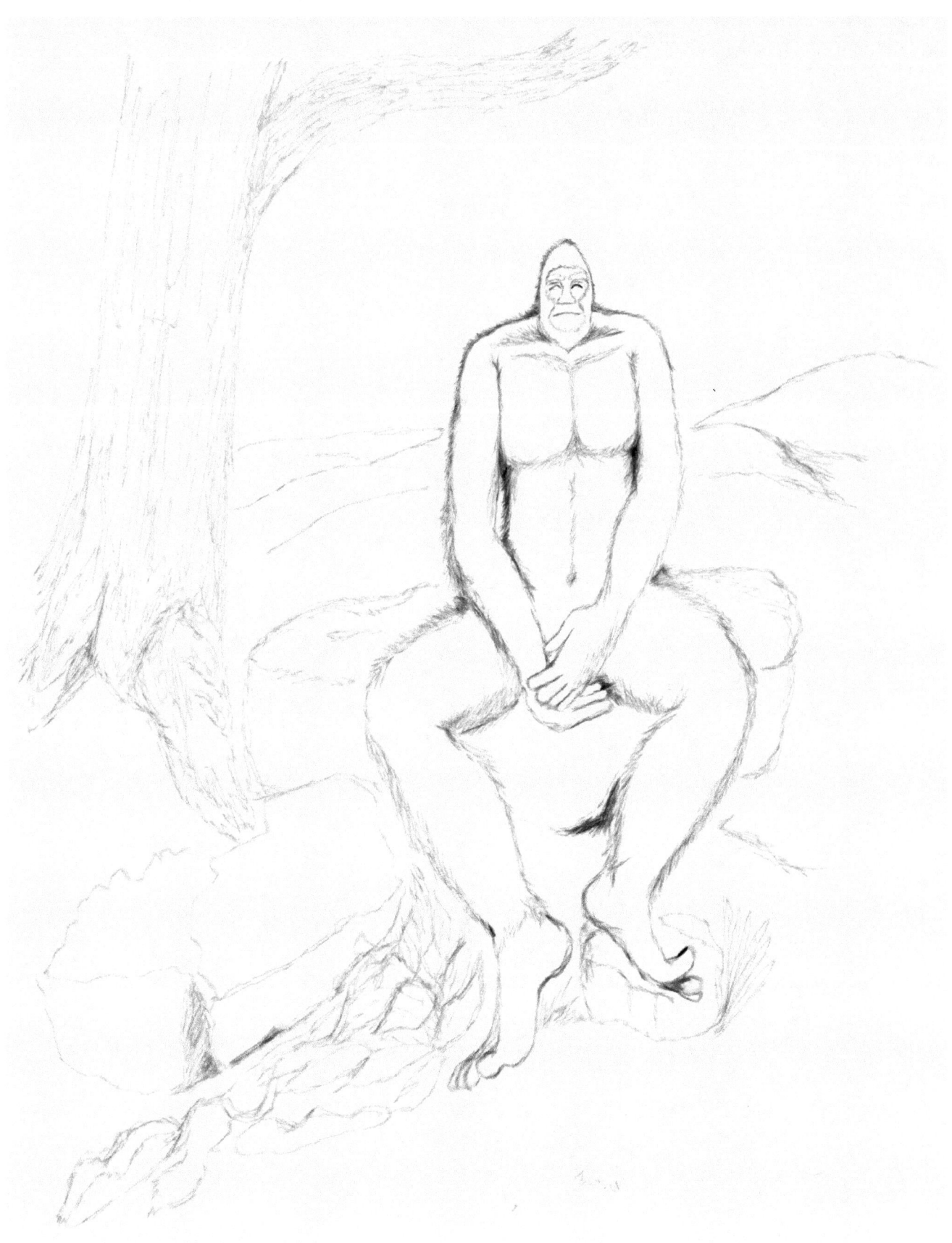

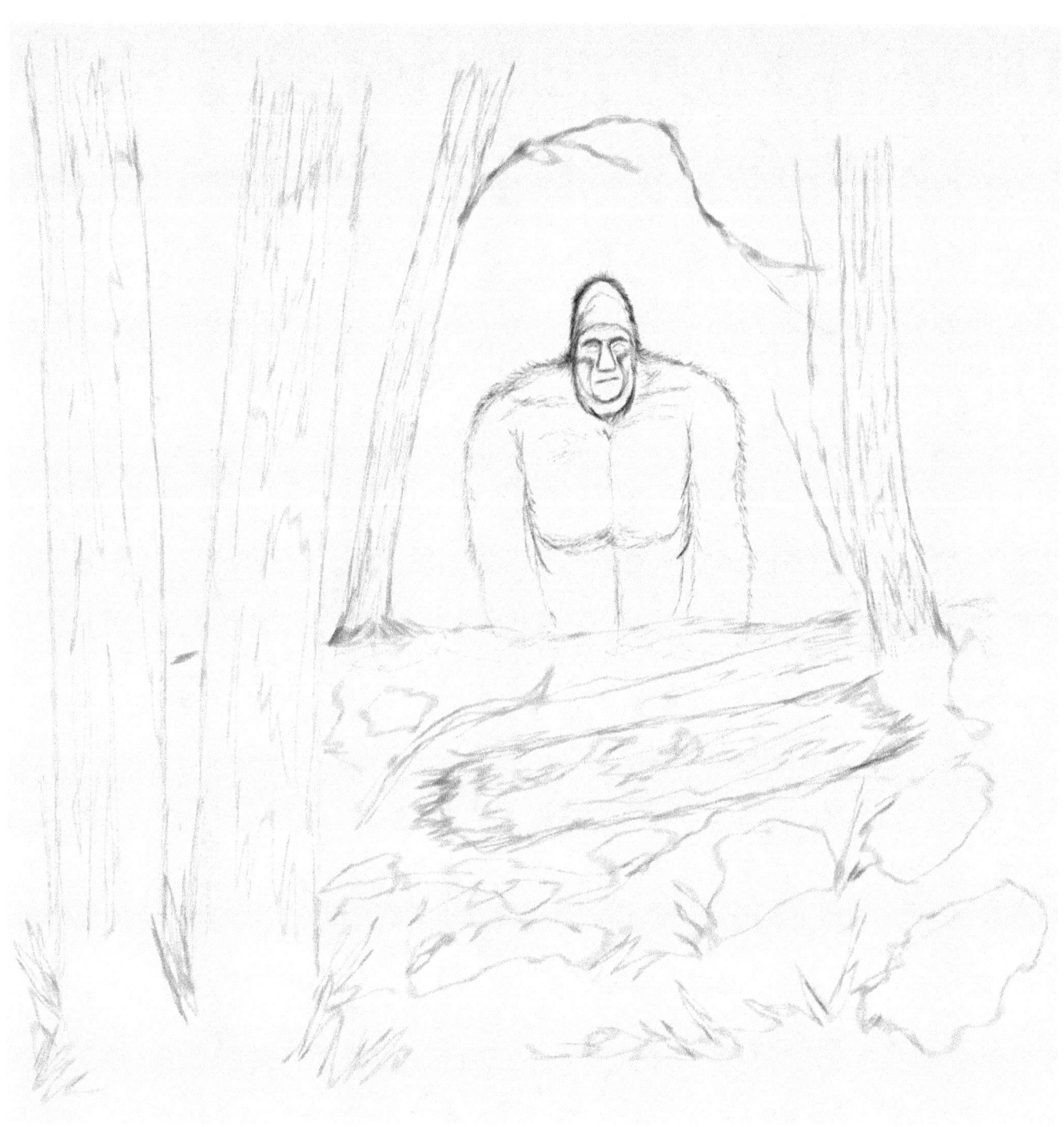

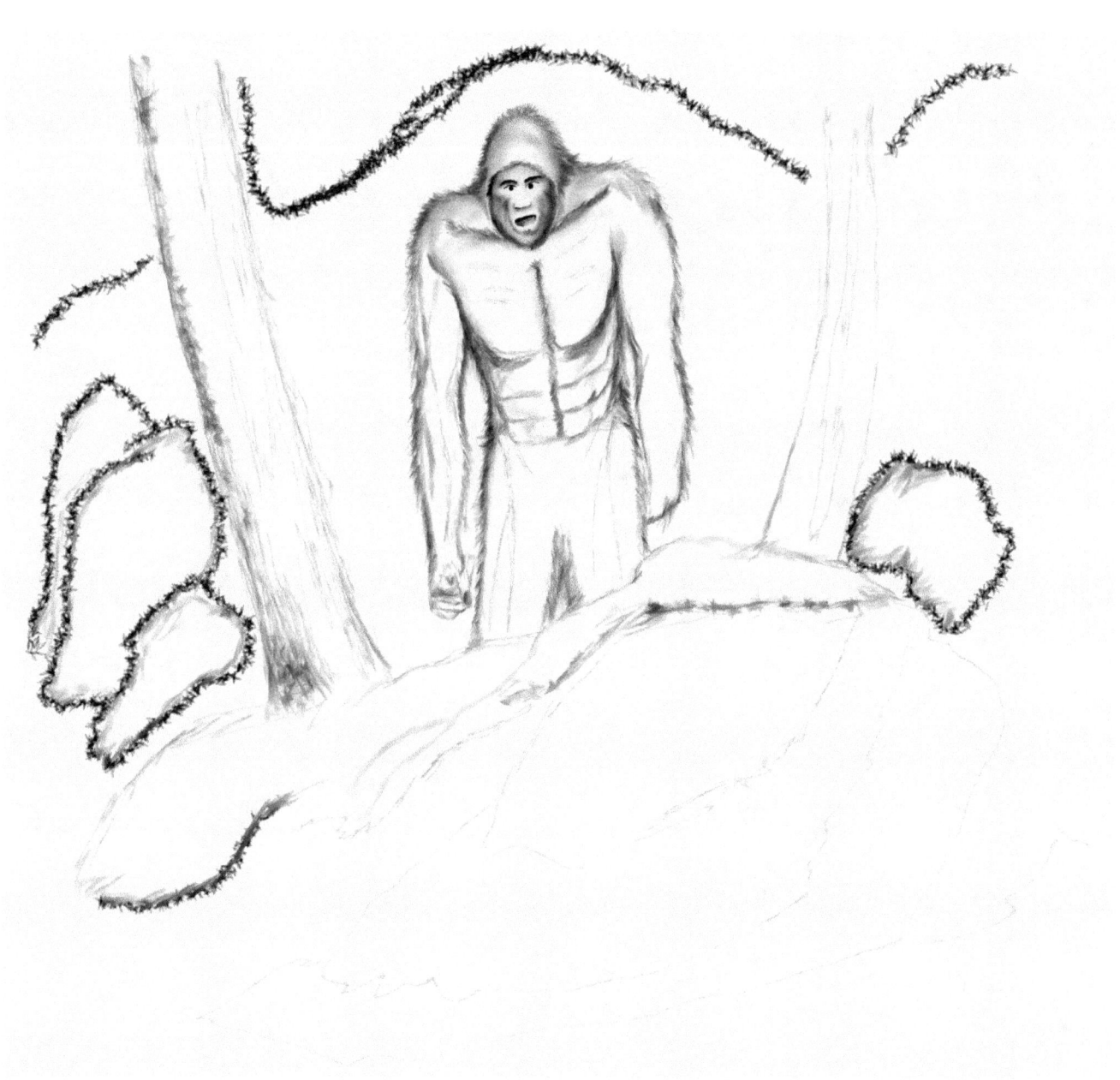

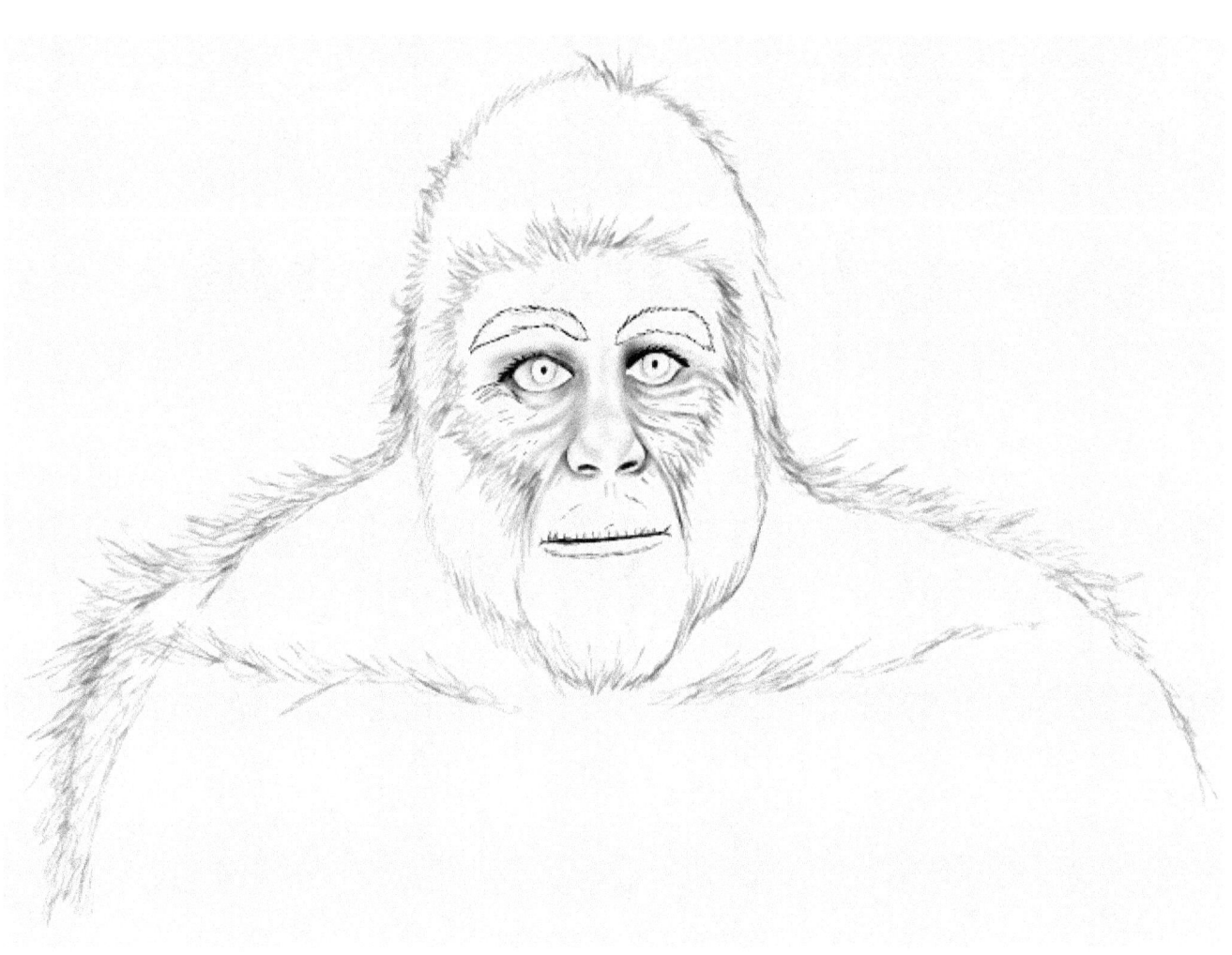

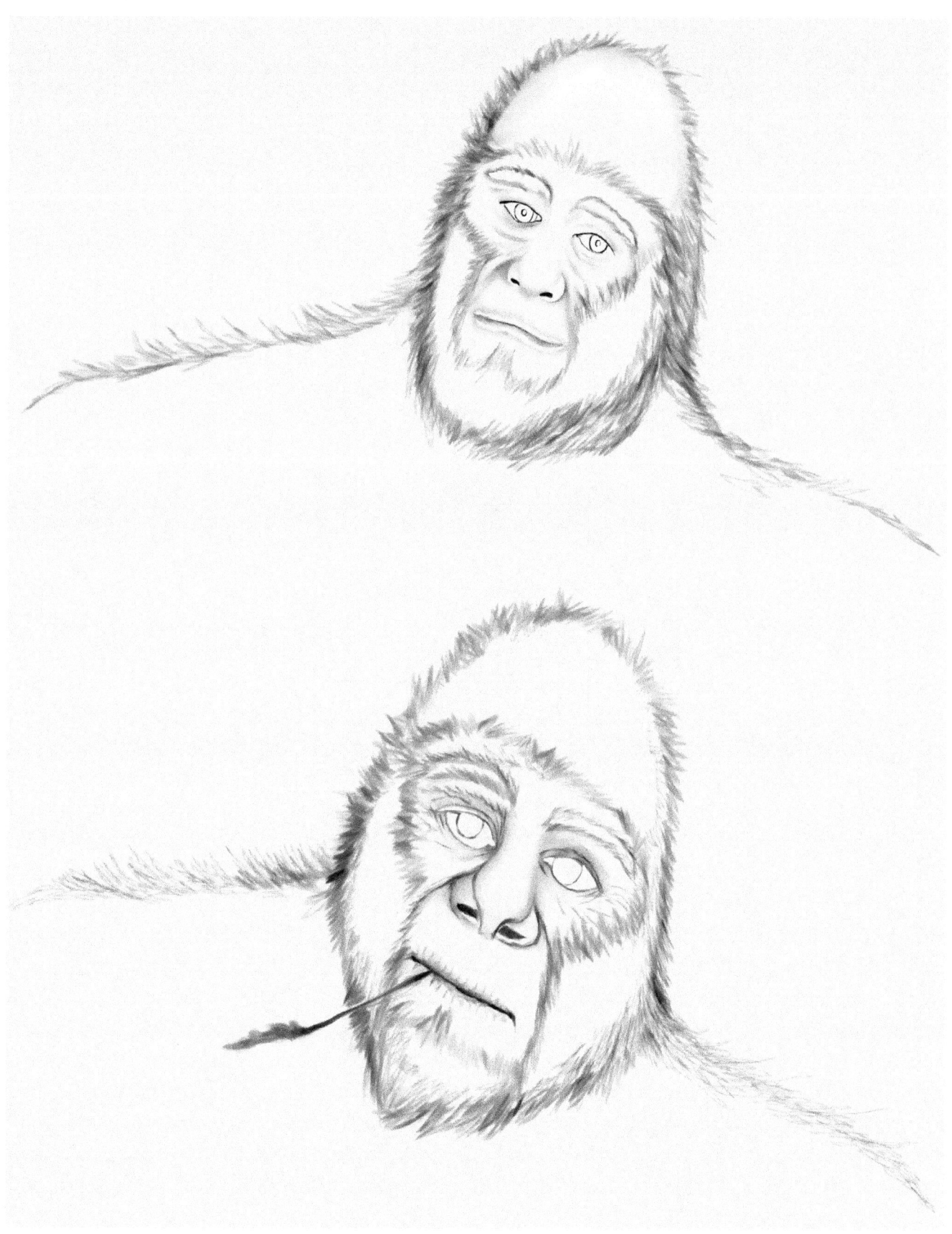

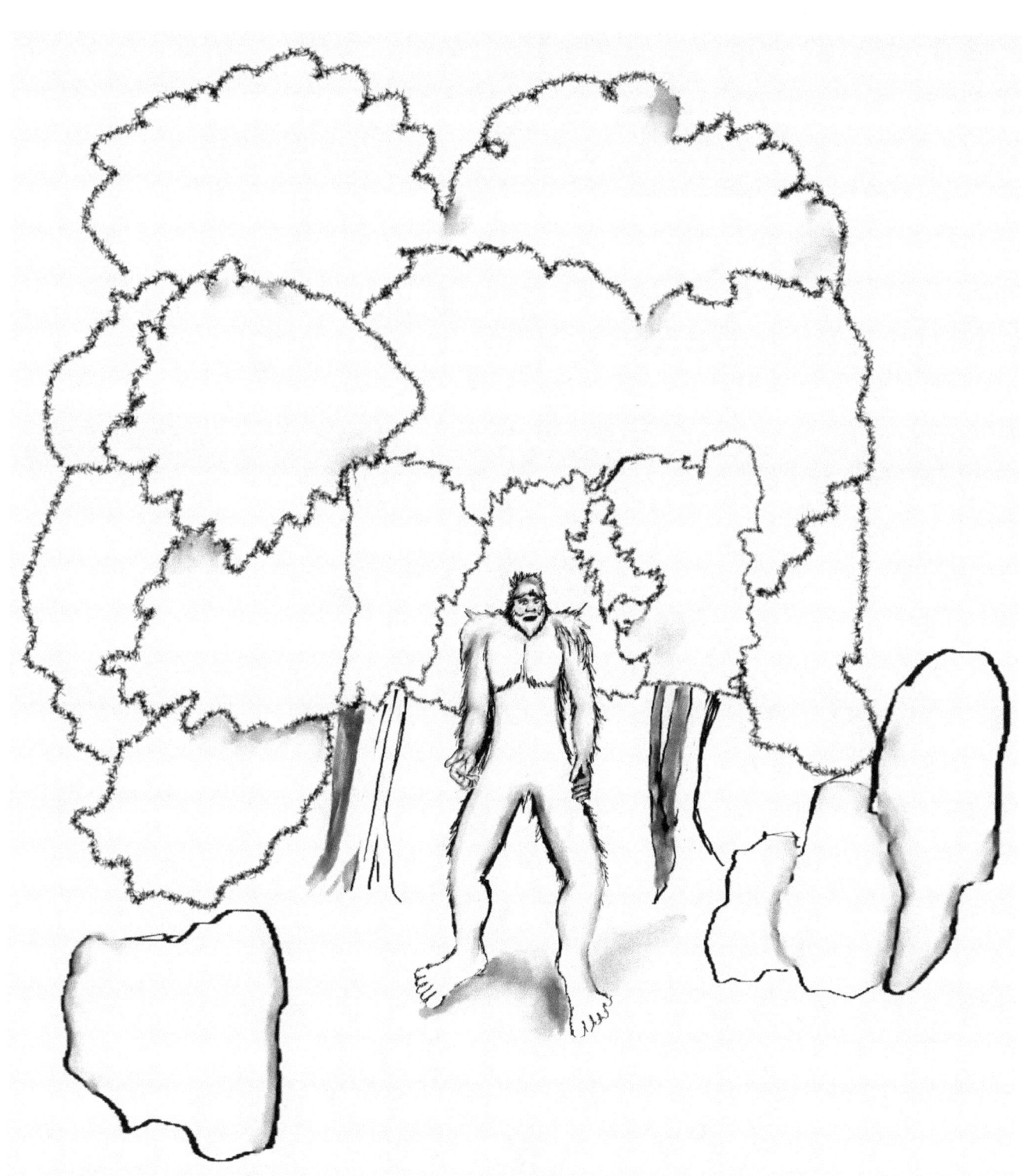

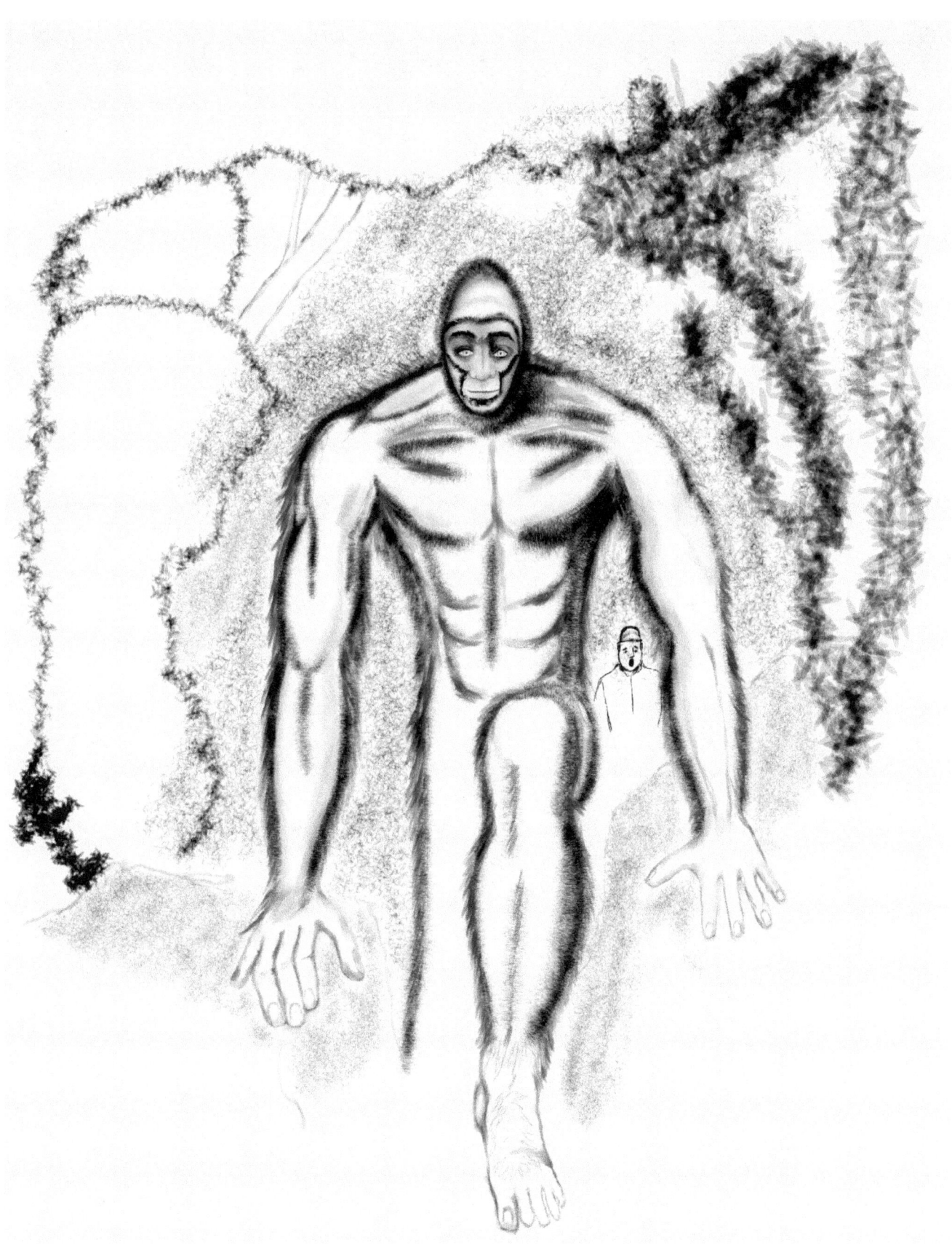

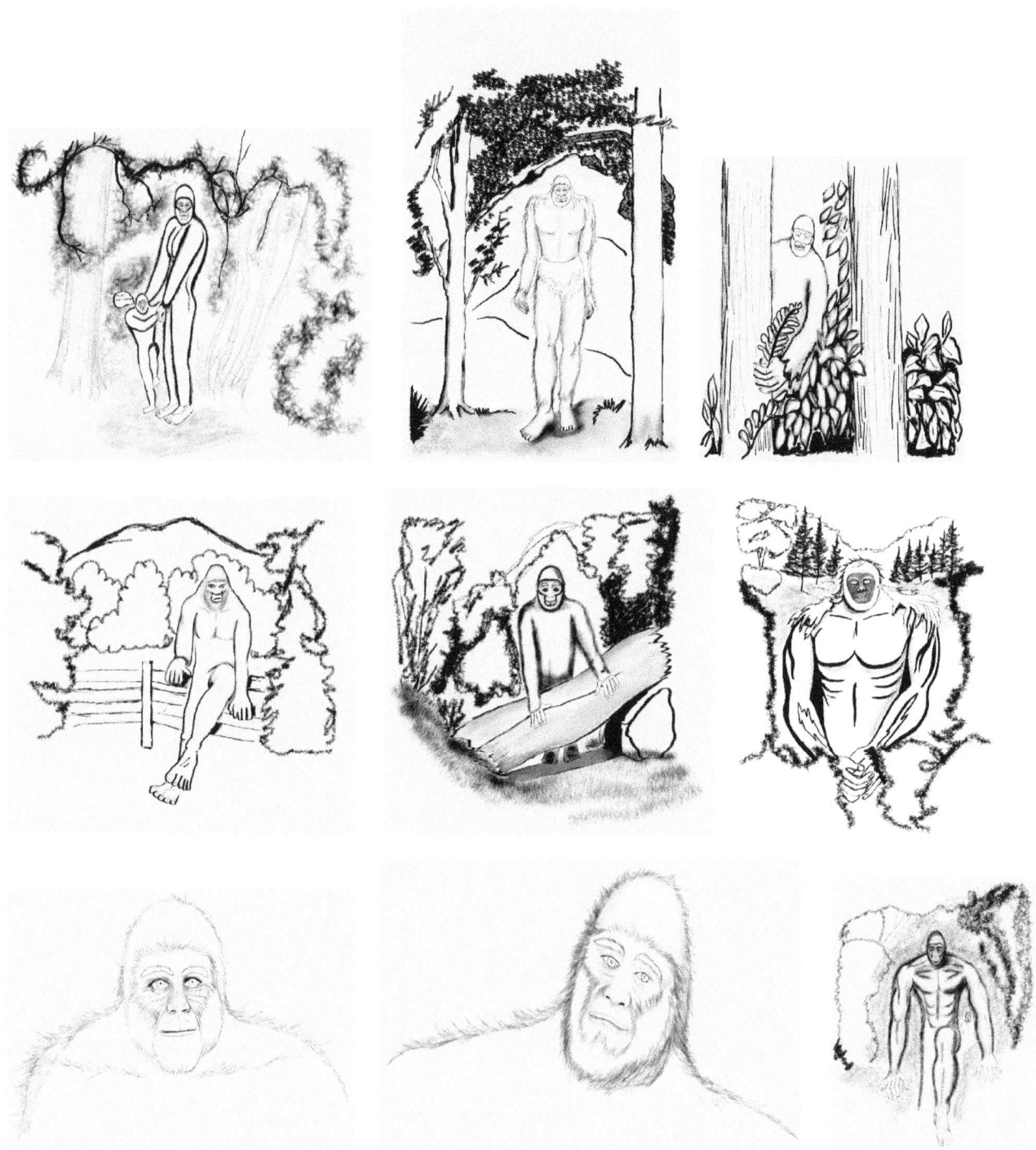

www.ingramcontent.com/pod-product-compliance
Lightning Source LLC
Chambersburg PA
CBHW080644190526
45169CB00009B/3493